SLANG TERMS COLORING BOOK

COLOR TEST PAGE

1960s

Gimme some skin

– to shake hands

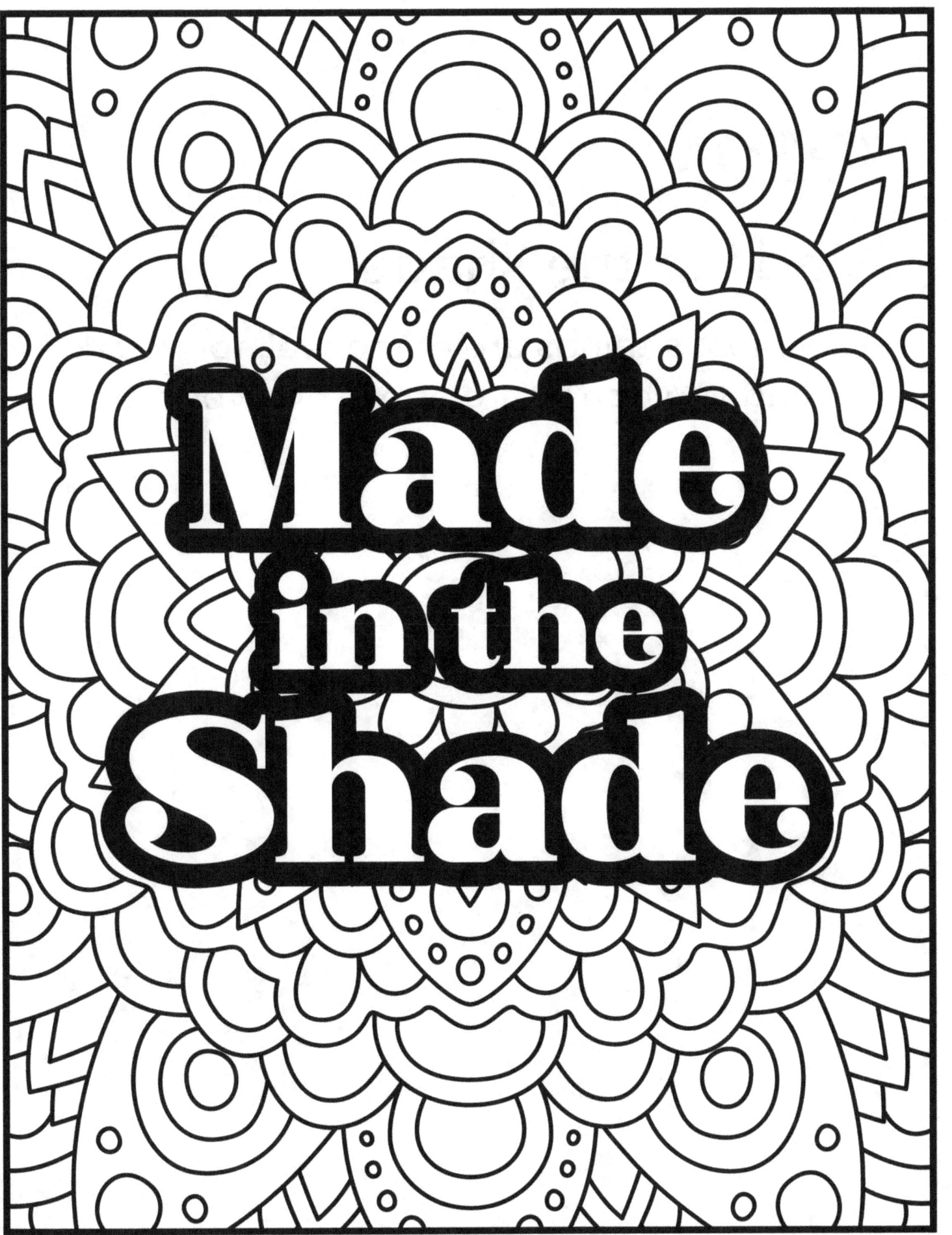

1950s

Made in the shade

— means things are going well for you and you don't care about everybody.

Damn Skippy

1990s

Damn skippy

- That's right.

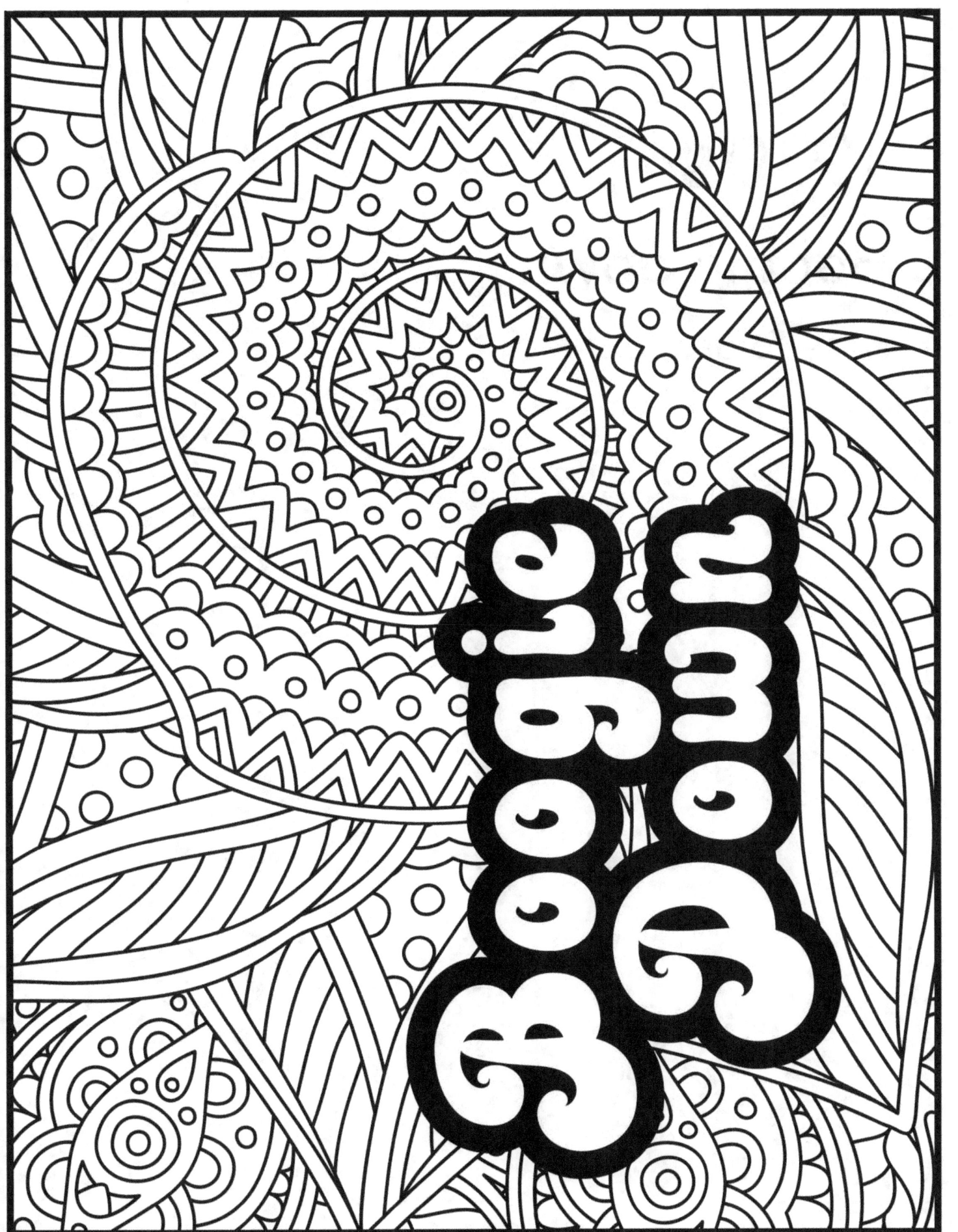

1970s

Boogie down

- To dance.

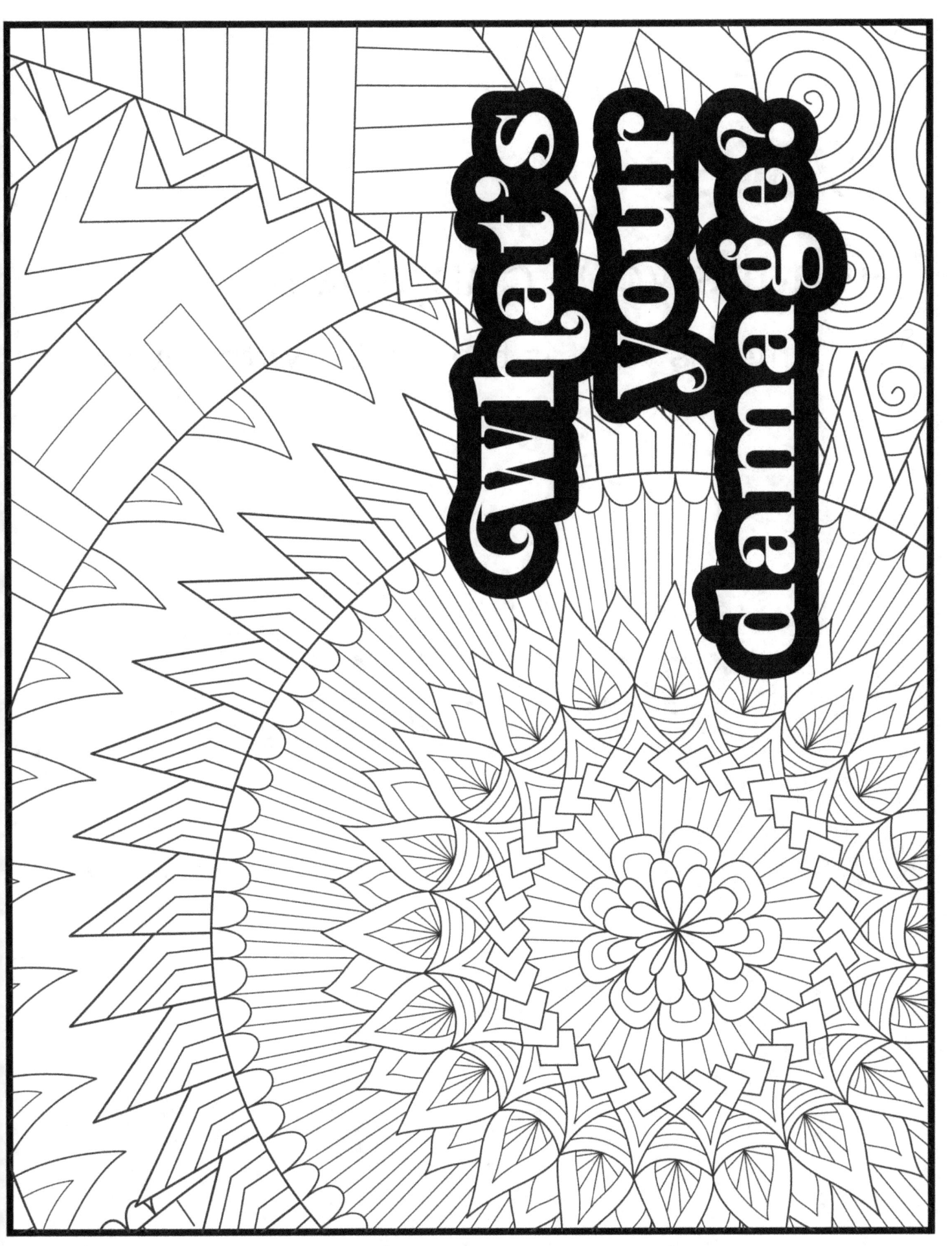

1980s

What's your damage?

– means what is the matter with you?

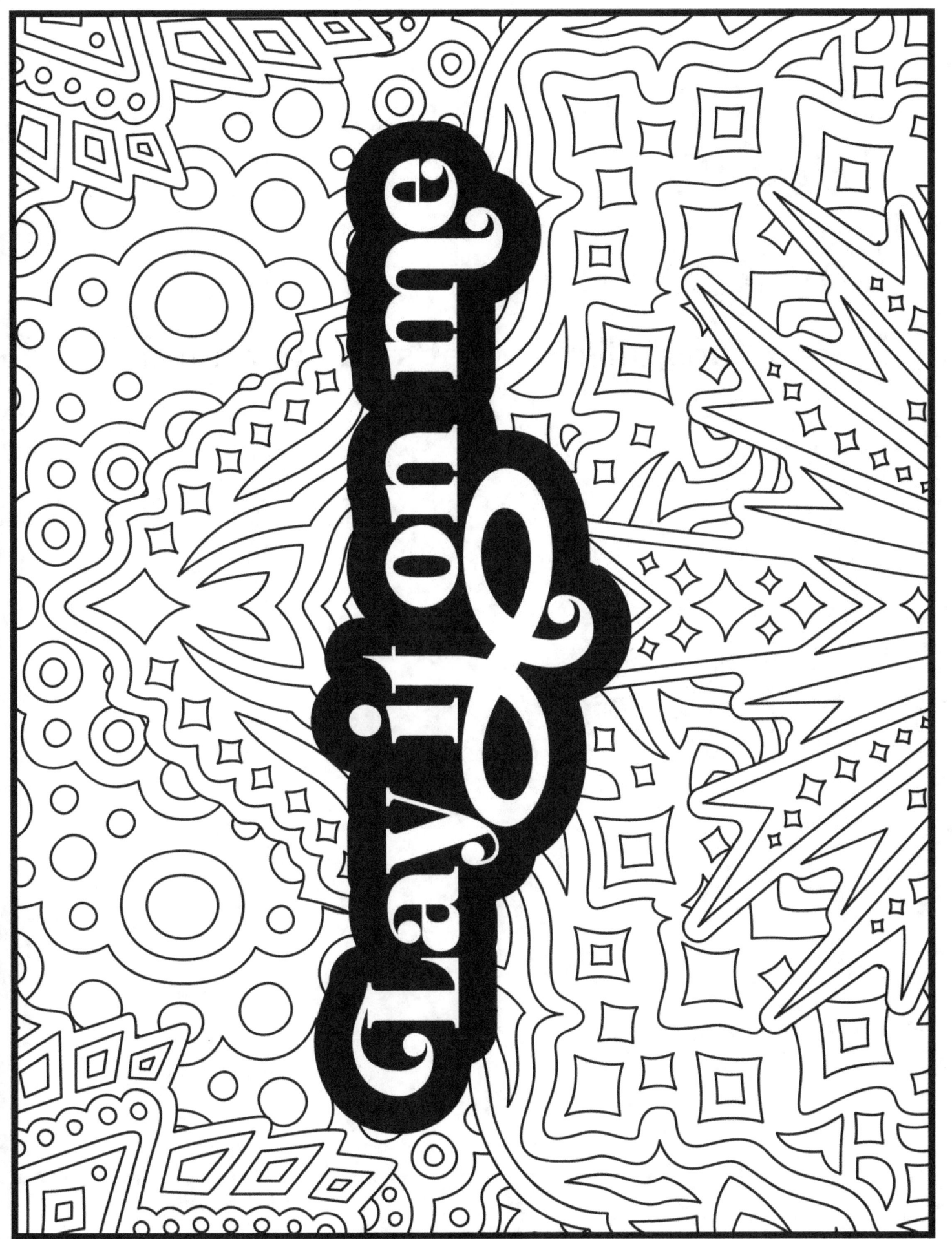

1960s

Lay it on me

– means tell me what's on your mind.

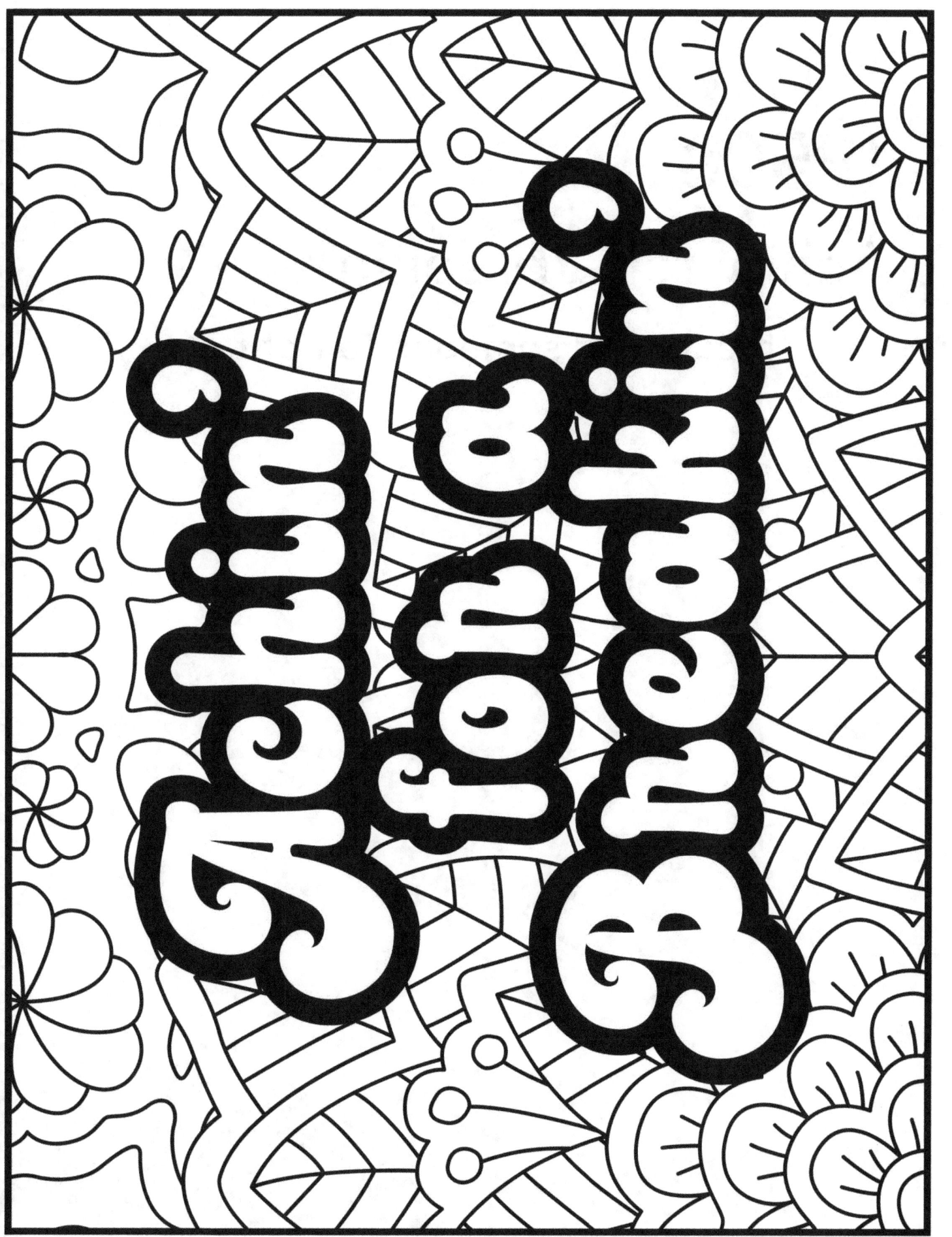

1950s

Achin' for a breakin'

– threatening someone to fight

1990s

Home Skillett

- a close friend

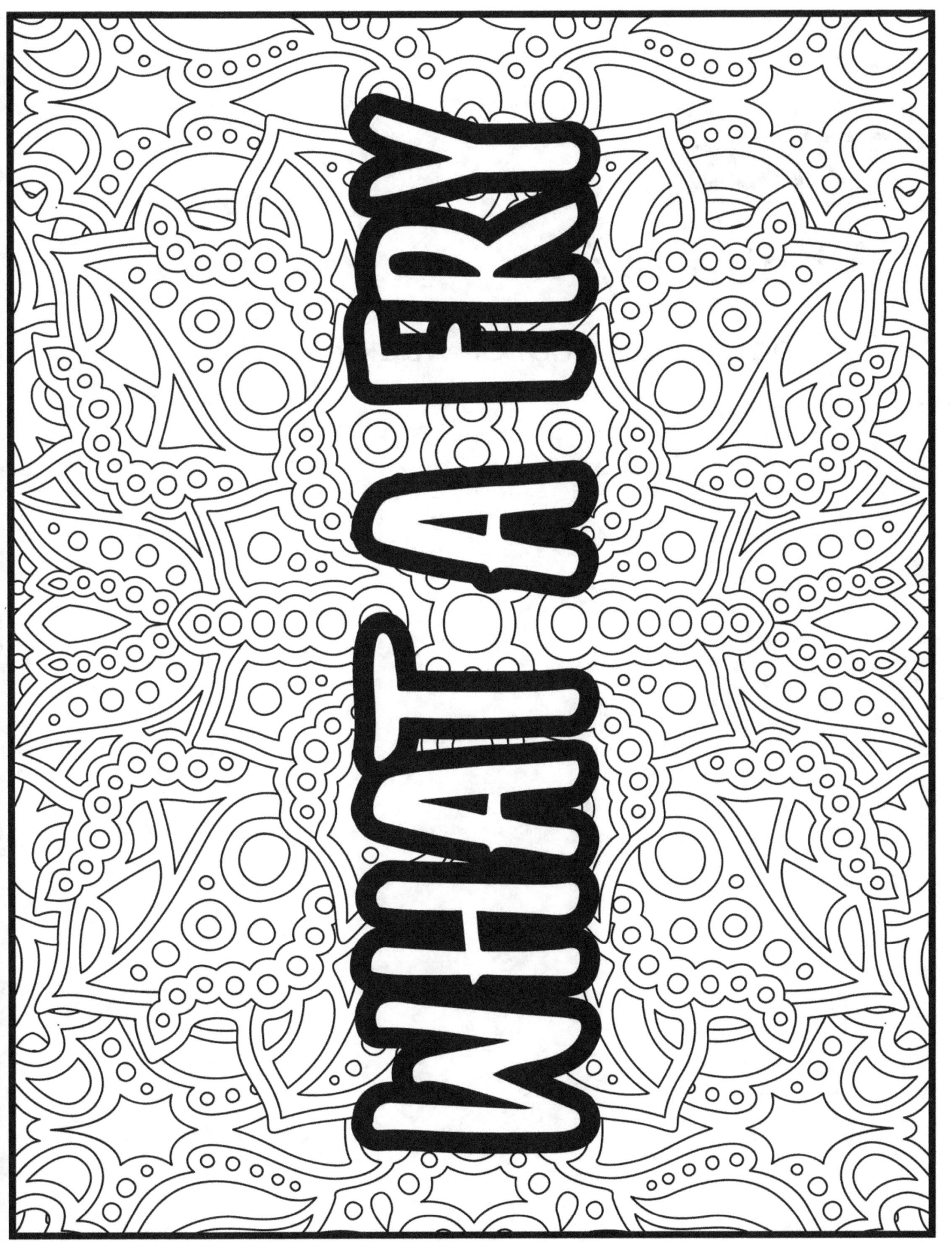

1970s
What a fry
- acting unusual or wacky.

1980s
Grindage
- acting unusual or wacky.

1960s
Blowing chunks
– throwing up

Word from the Bird

1950s

Word from the bird

- assure someone that you're telling the truth

Straight Edge

1990s
Straight Edge
- doesn't do drugs or drink

1970s

Cool beans

- means that's great

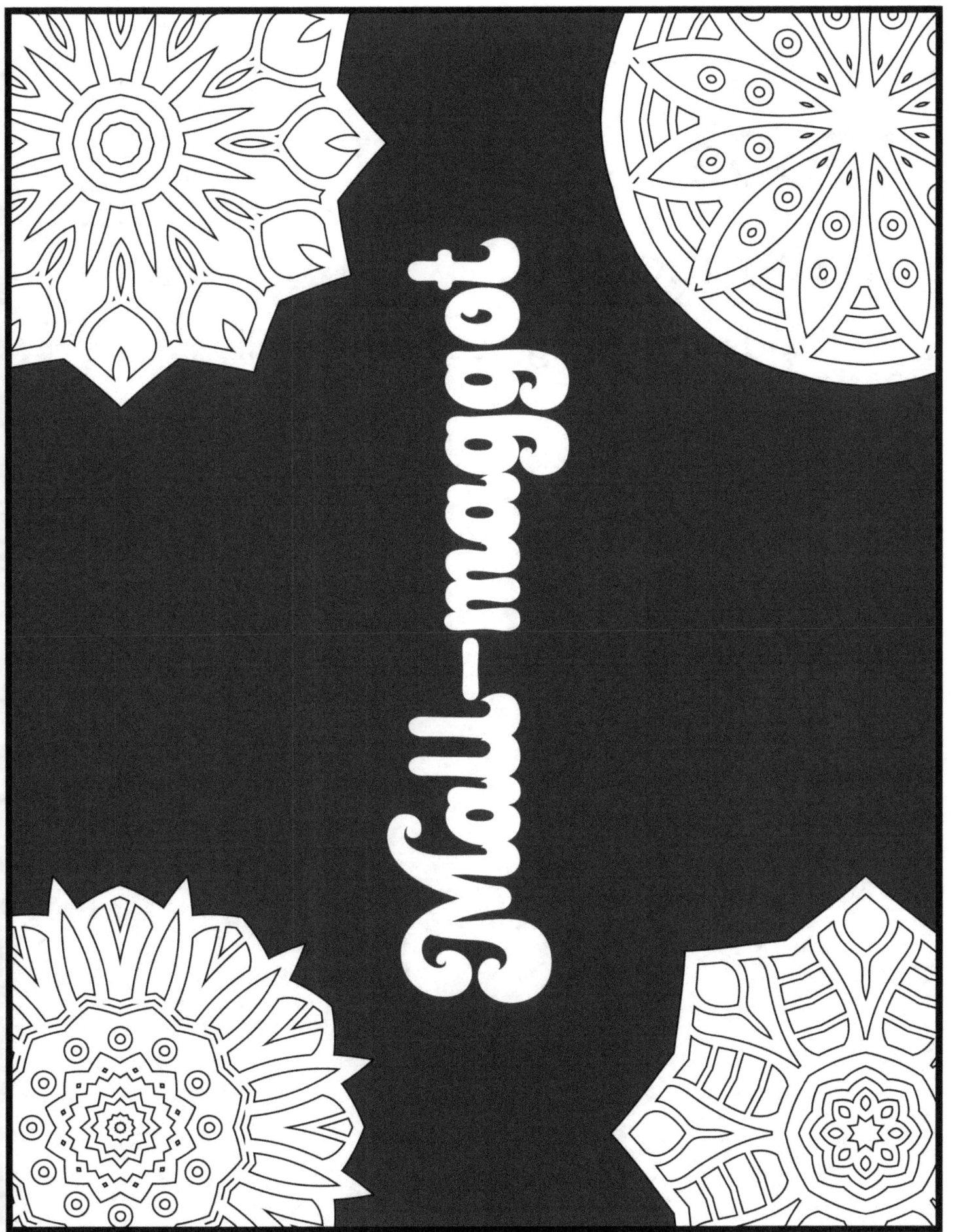

1980s
Mall-maggot
- kids who hang out at the mall

1960s

Catch some rays

– to get some sun

1950s

Beat feet

– to get away fast

1990s

Let's bounce

- you say when you want to leave

BRICK HOUSE

1970s
Brick house

– term used to describe someone who is built well or good-looking body

1980s
Ooglay
– extremely ugly

1960s

Outta sight

- great or fantastic

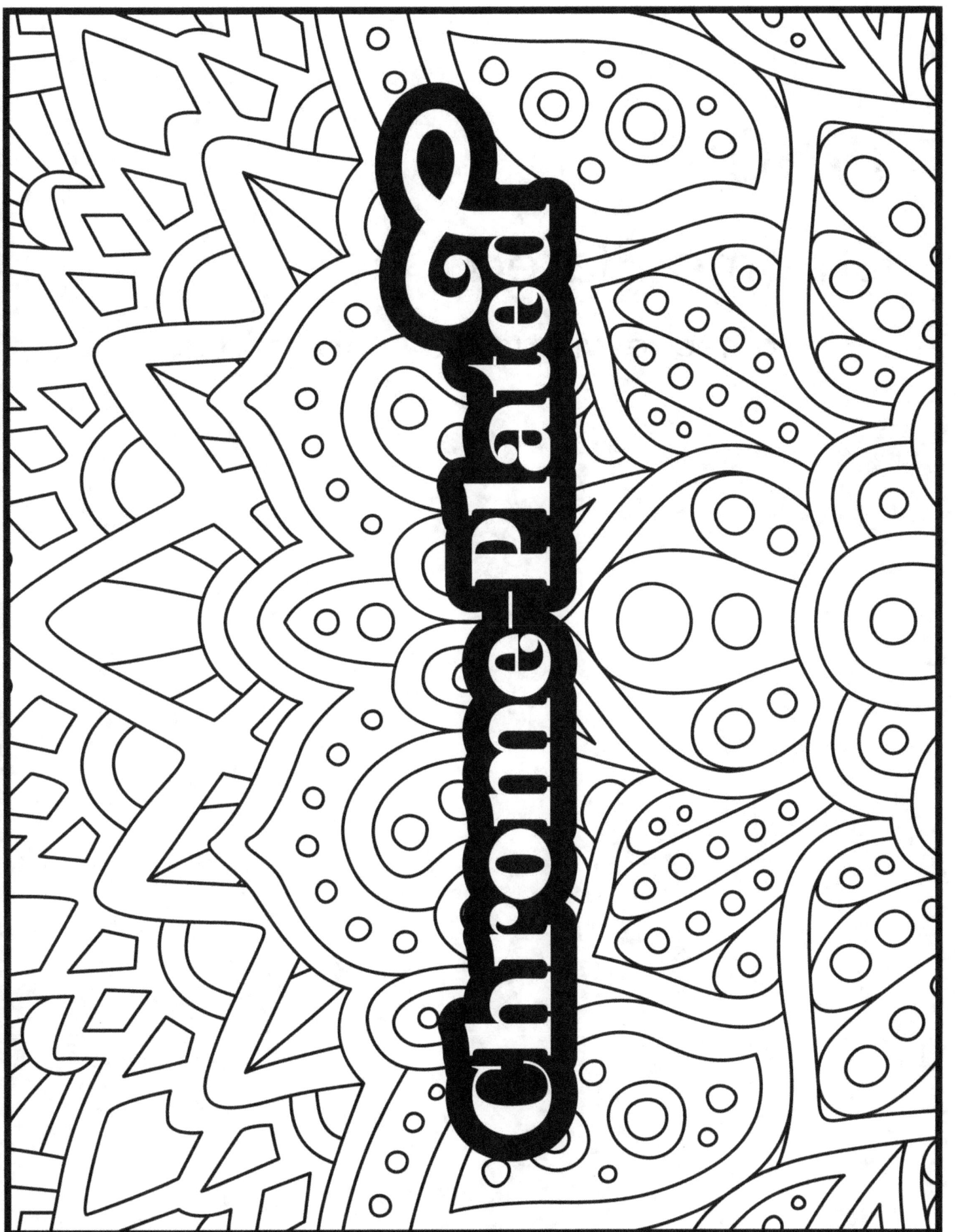

1950s

Chrome-Plated

- someone who is really dressed up

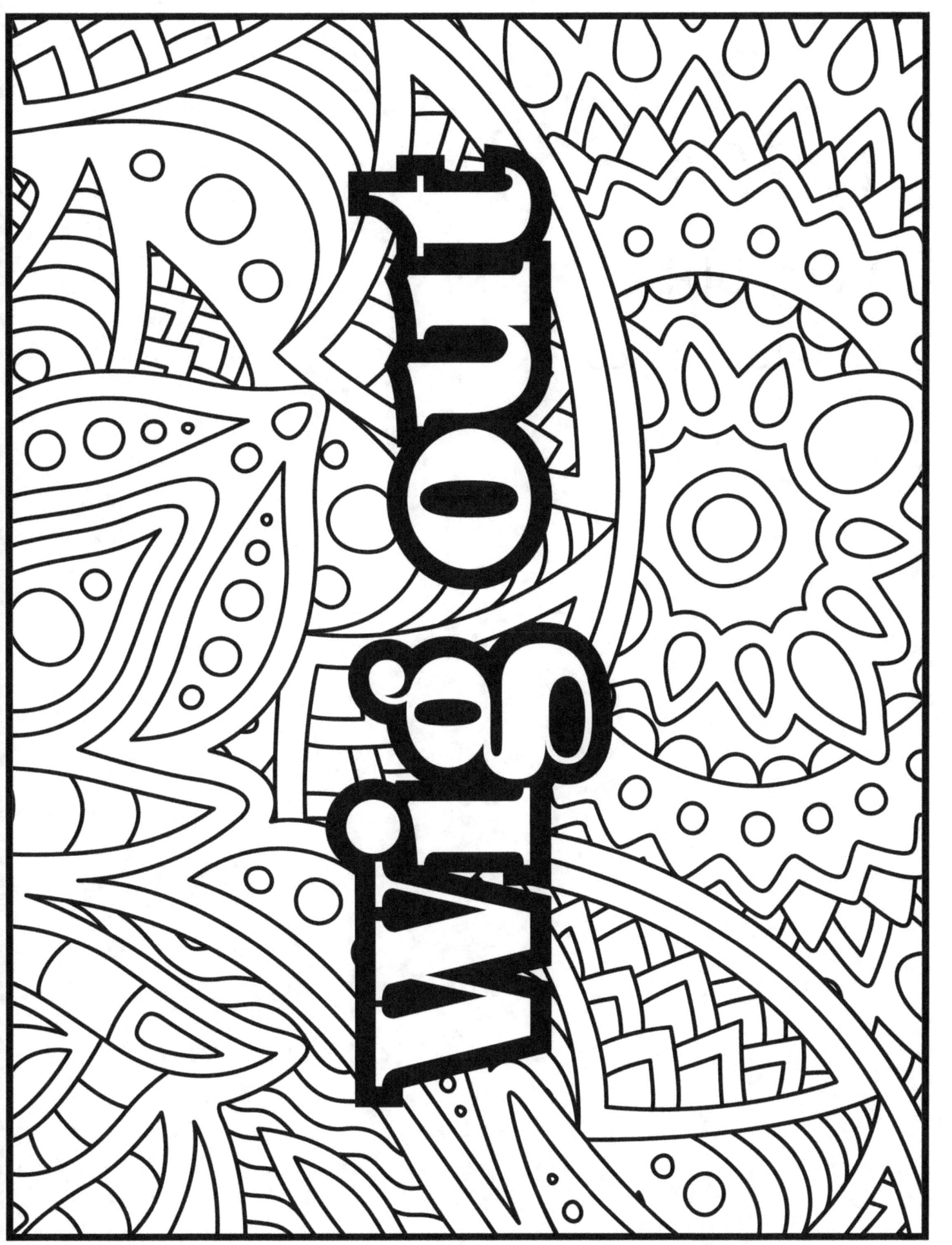

1990s

Wig out

- to freak out

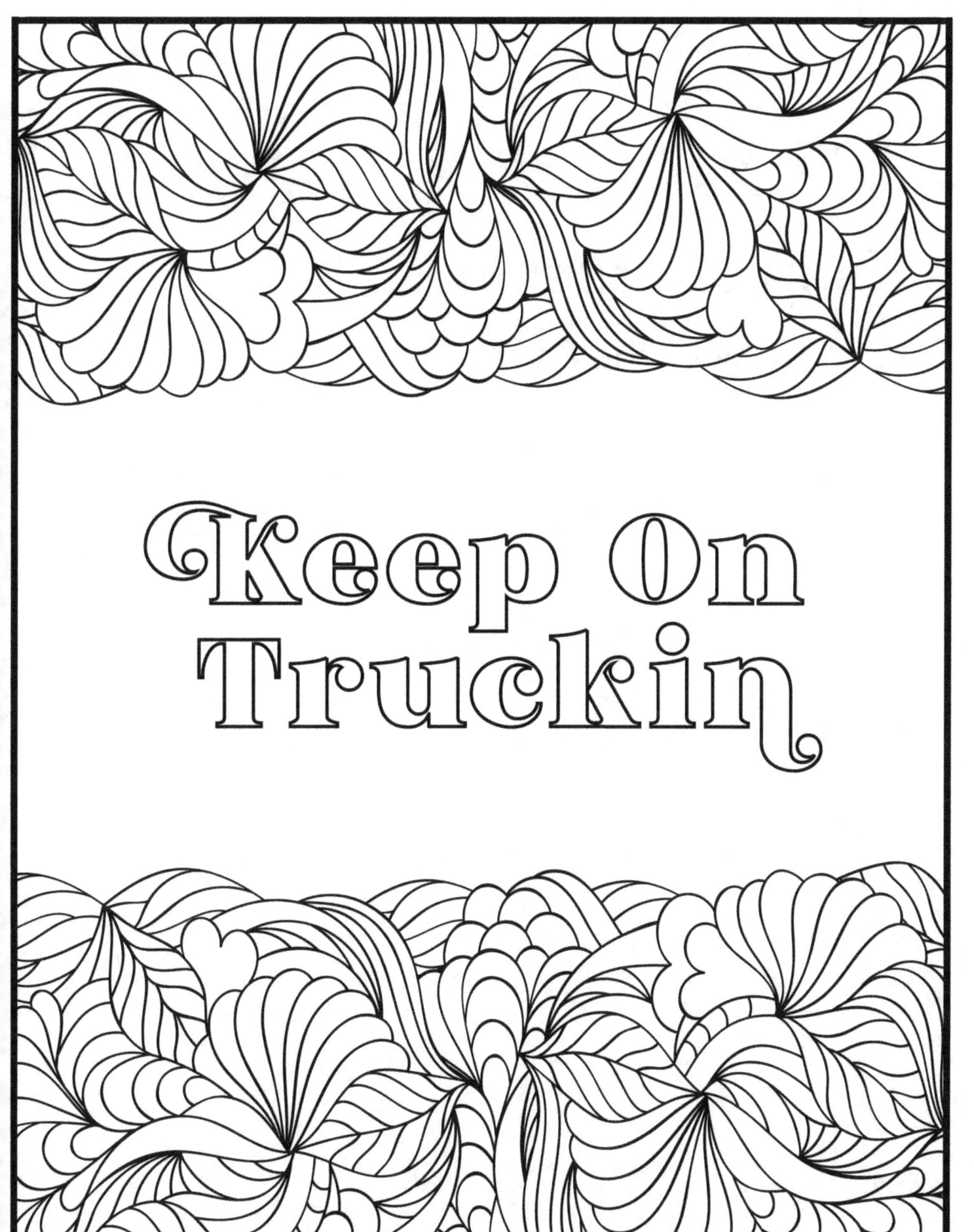

1970s
Keep on truckin
- go with the flow

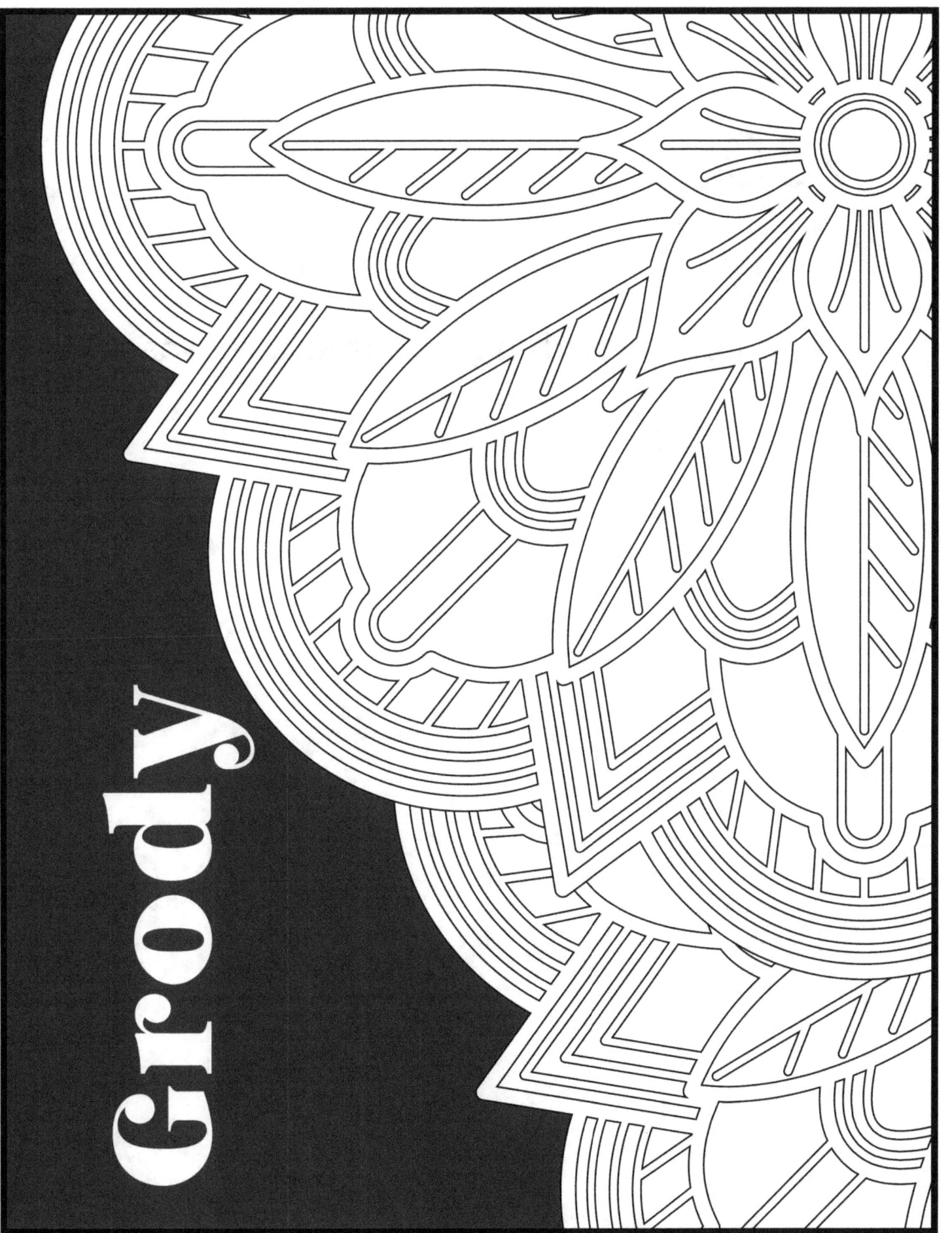

1980s

Grody

- to call something or someone gross

1960s

Flippin

- something that is fun or cool

1950s

Cut the gas
– be quiet!

1990s
Phat

- cool or awesome

Be There Or Be Square

1970s

Be There Or Be Square

- means be at the party or place or be boring!

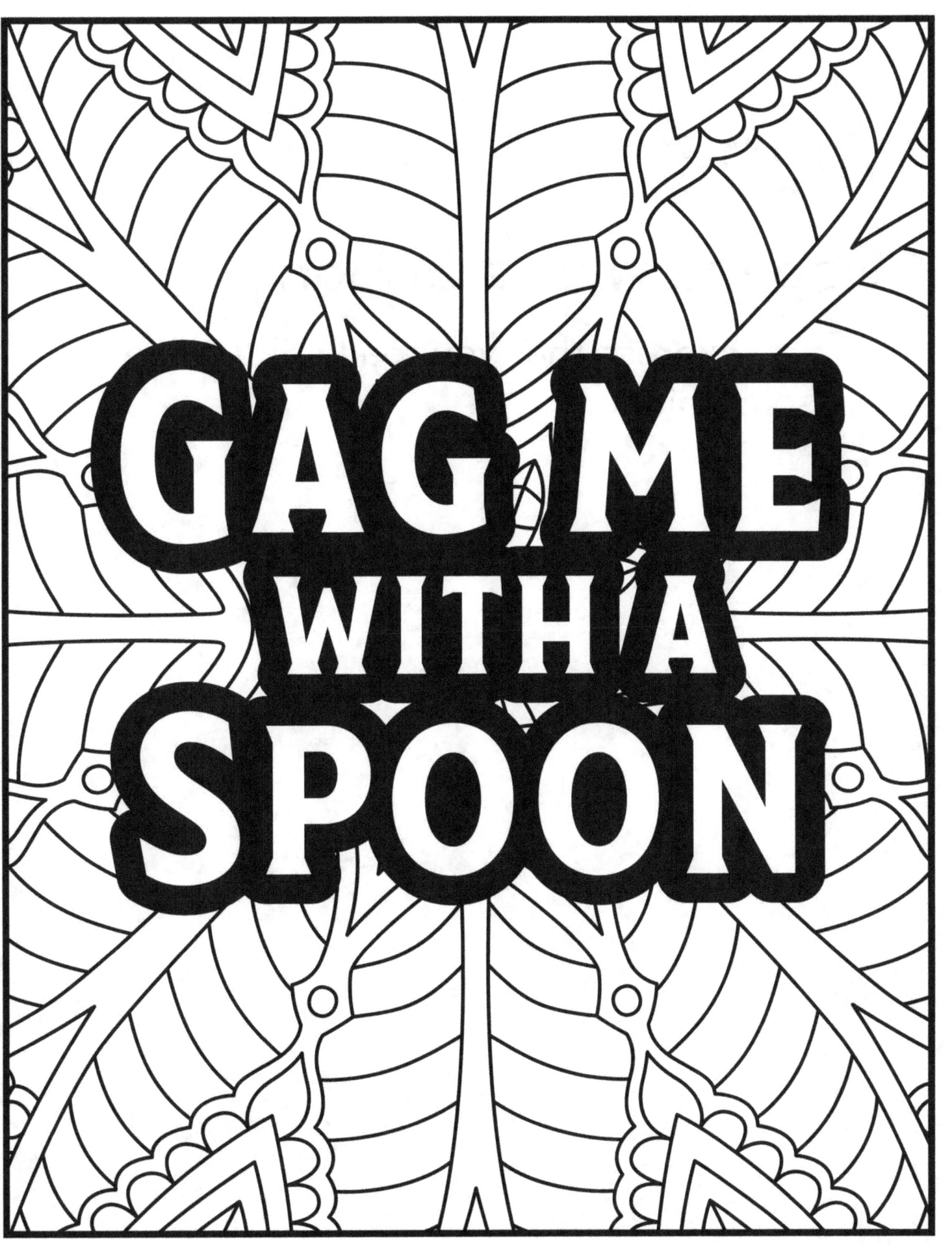

1980s

Gag me with a Spoon

– to express that you really didn't like something

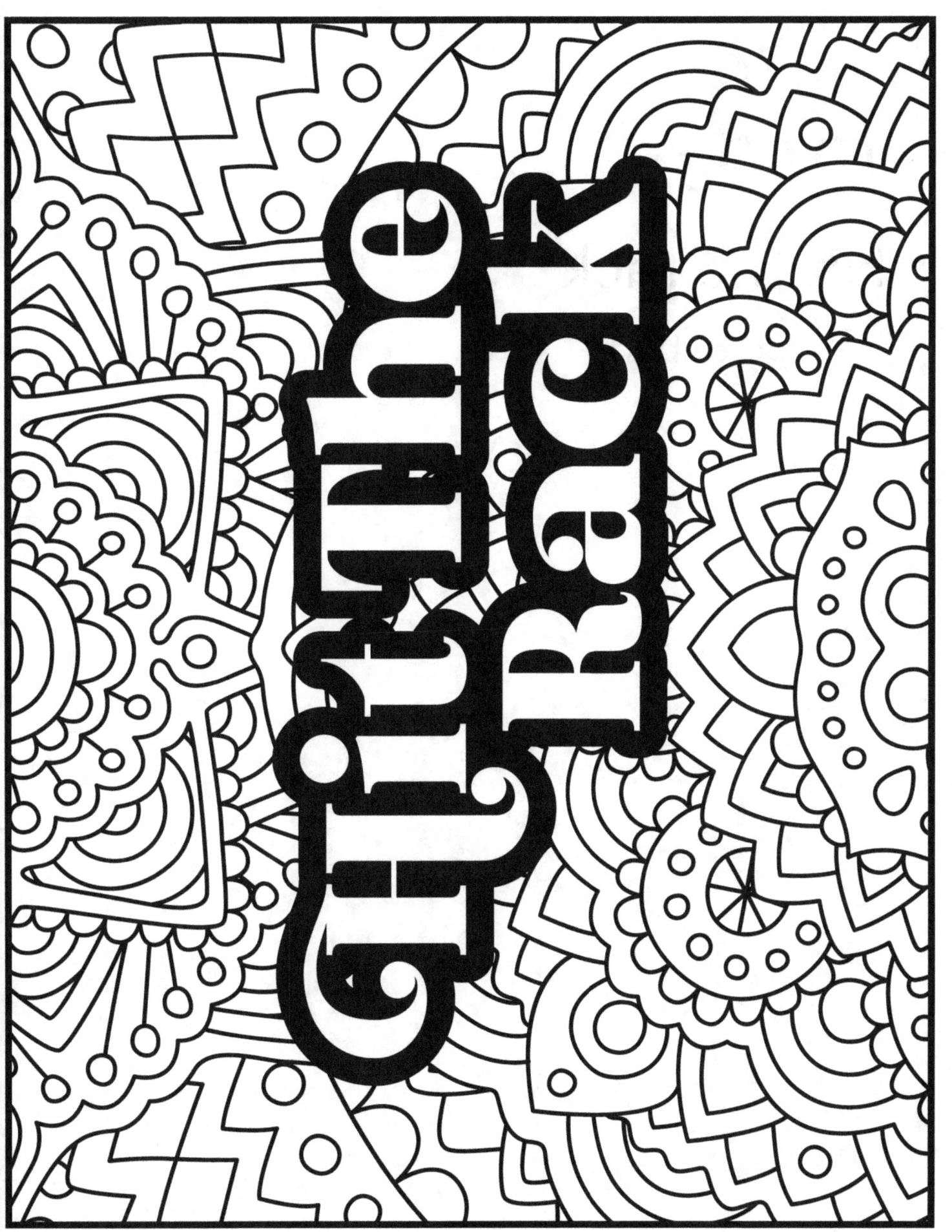

1960s

Hit the rack

- go to bed

1950s

Classy chassis

– means great body

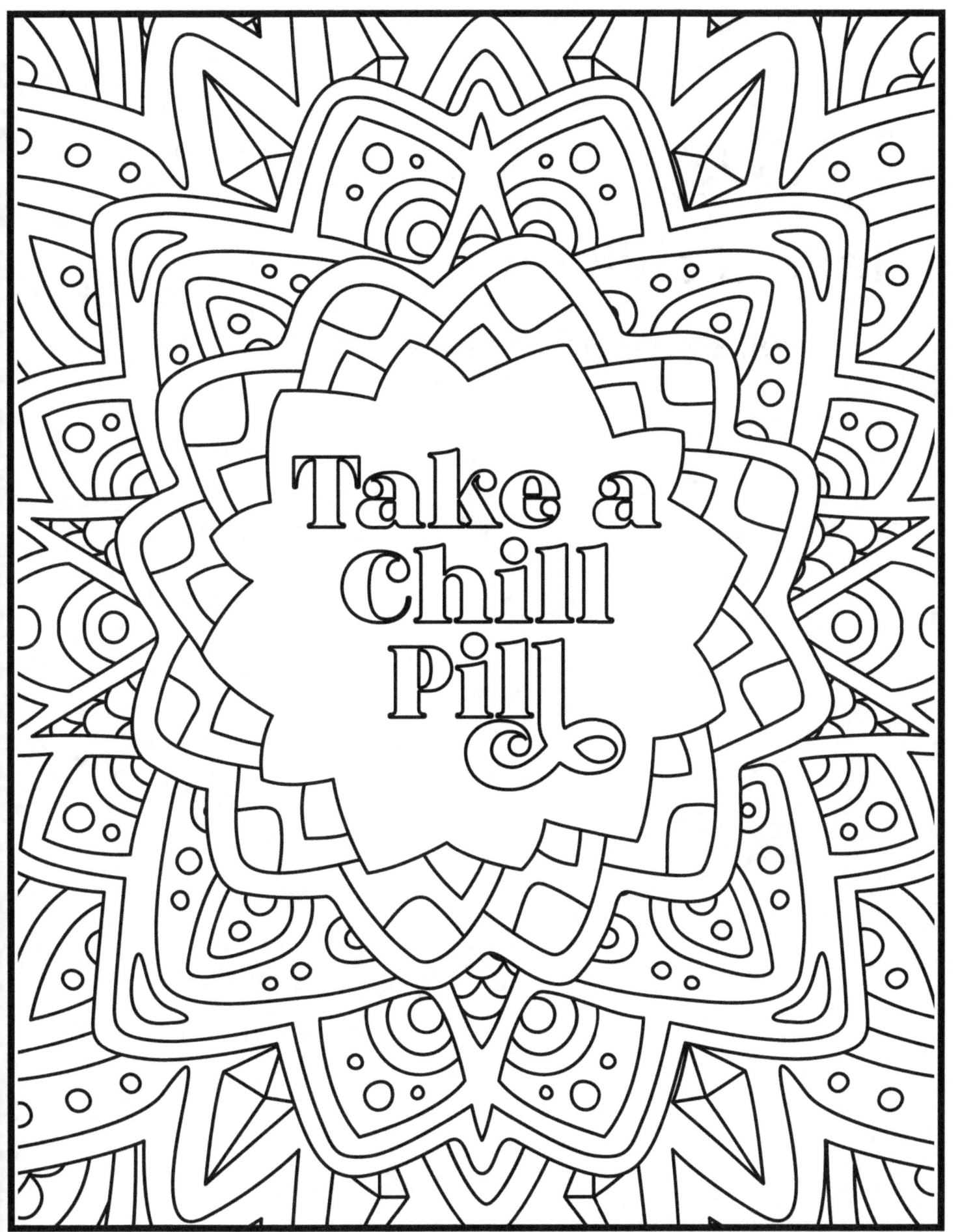

1990s
Take a chill pill
– tell someone to relax

1970s
Freaky-deaky
- very weird

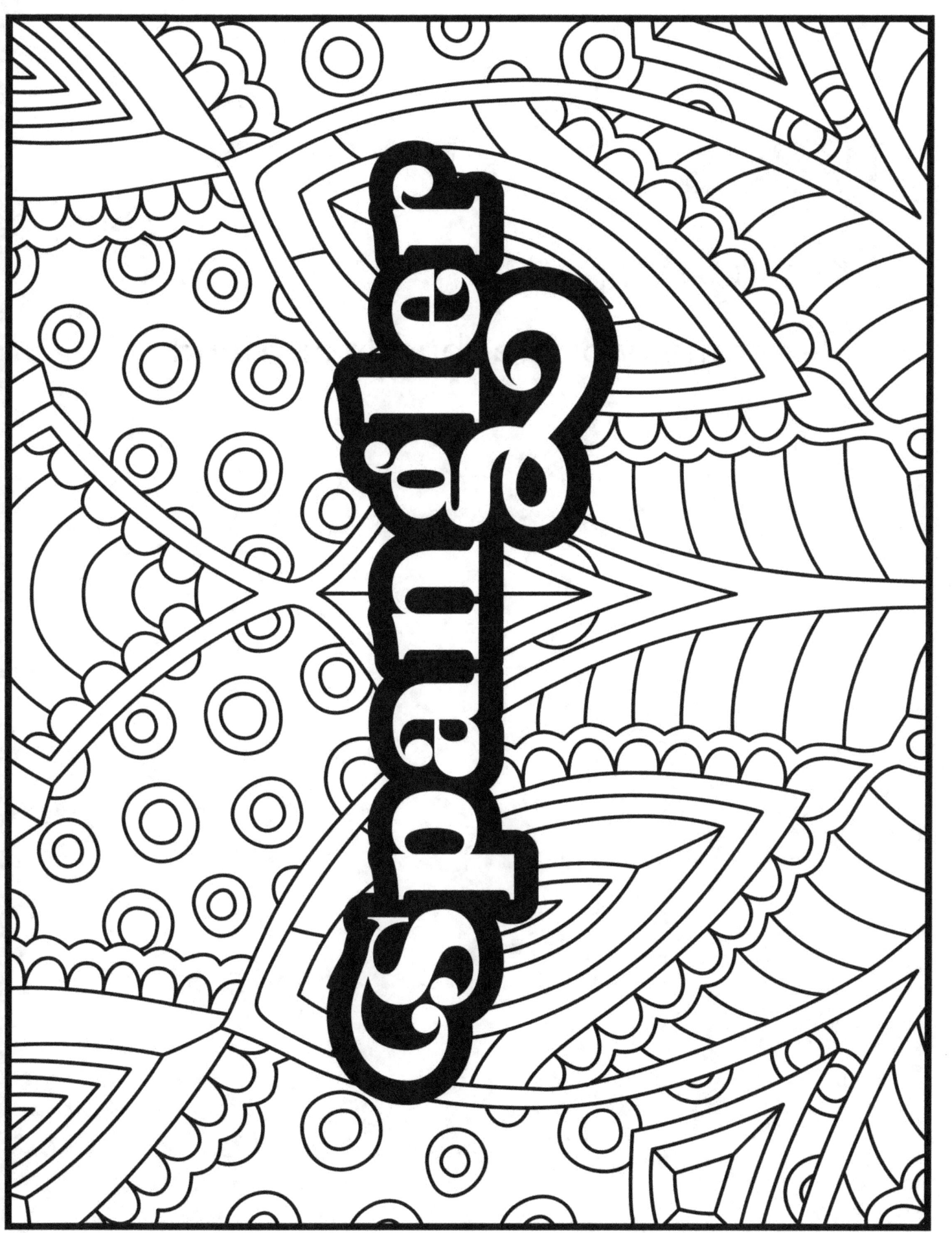

1980s

Spangler

- another word for buddy or friend

www.ingramcontent.com/pod-product-compliance
Lightning Source LLC
Chambersburg PA
CBHW081456220526
45466CB00008B/2664